NEW YORK WATERWAYS

NEW YORK WATERWAYS

SUSANNAH RAY

HOXTON MINI PRESS

This book is available as a collector's edition

www.hoxtonminipress.com

From the series

TALES FROM THE CITY

Book Five

INTRODUCTION

by Marie Lorenz

New York City lies at the heart of a great tidal estuary. Its deep water, sheltered bays and sandy beaches might seem insignificant when talking about a global megacity, but these geologic features have shaped its history more than its legendary bedrock. Surrounded by water, land in New York was always scarce. The population density has demanded infrastructure that is often the first of its kind: one of the first modern aqueducts, the first vehicular tunnels, the largest rapid transit system, and time after time, the greatest bridges. Bridges are a historic symbol of this city: leaving the barrier of water far below, they are towering reminders of our dominion over nature.

These are the bridges in Susannah Ray's photographs. Far in the distance, sometimes out of focus, they are not only symbols, they serve as practical landmarks for the viewer and subject, helping determine our position in a shifting landscape. These images express the city's relationship with nature not as a beneficial transaction wrapped up before we were born, but as a tangled embrace, evolving over centuries, cluttered with plastic and rotting infrastructure, well-worn with common use. In one photograph a modest picnic is set before a pretty waterfront view. On a sloping cement incline, the fast food package of someone's lunch merges with a few wrappers left behind. It looks like a popular spot, caught in the rare stillness of early morning shade. In the distance, the Cross Bay Bridge. We must be in Queens.

Hurricane Sandy changed the way we think about New York, but while most people were talking about fragile infrastructure and the need to change our physical landscape, it brought Ray closer to her human subjects. Susannah Ray's neighbourhood in Rockaway was among the most impacted by the storm and throughout the year she watched her neighbours, and her own family, resume their lives. The water had destroyed so many households, and yet here they were, swimming, fishing, boating, heading back out into the water's healing embrace.

Urban waterways are often seen as something to admire but never touch, and Ray's subjects are happy to disrupt this perception. They are fully immersed, wading, hugging, worshipping, bodies engaged with nature. In one photograph, a swimmer looks back at the camera, confident, powerful, relaxed; her composure in this portrait seems so much like an Olympian before the 100-metre relay that I almost forget to see the rest of the picture. Her body rests on the bulwark of a rough commercial vessel. Miles in the distance, the Verrazano Bridge blurs out above the horizon. It seems impossible, but the swimmer is preparing for an open water swim in the middle of the New York Harbour. In another photograph, a man looks out across the water, his dogs mingle at his feet. The ocean horizon is clear, flat, no bridge in sight to give us our position. We might be on a beach in any part of the world.

One place recurs throughout the book, a tidal inlet in Rockaway, the fibreglass skeleton of a motorboat and chipped concrete frame the reflected sky. We see the basin four times throughout the year, and at different stages of the tidal cycle. Repetition invites us to examine every aspect of the shot. It reminds me of a boat trip that I took with Susannah Ray in 2015. We launched

from a little sandy beach at the mouth of Coney Island Creek. It's not the kind of place you'd ever wind up unless you lived close by or are attracted to this type of thing. We floated past a gas station, shipwrecks, old cement grain towers leaning along the horizon, and passed under the bridge on Stillwell Avenue. The water was thick with floating oil and drifts of dirty plastic, the unintended consequences of human progress. Susannah looked up at a billboard, realised that she had photographed this very spot from shore and exclaimed, "I've always wanted to be here."

PHOTOGRAPHER'S NOTE

by Susannah Ray

Walt Whitman, in his 1856 poem "Crossing Brooklyn Ferry," ecstatically invokes New York City's waterways. Passionately, deliriously, Whitman calls out to the tides, the gulls, the ferry passengers, the light, the clouds, the ships, the sailors, the waves, the cities on the far shore. All humans are divine in his eyes, their reflected faces anointed by "fine spokes of light" in the passing waters. "Suspend," he cries, celebrating these moments unmoored from the sure time of the city.

Inspired by the unfettered humanism of Walt Whitman and by the shifting light and reflective waters of American Luminism, I have gathered these images of life upon and alongside New York City's waterways. The distant spires of Manhattan appear from across bays and harbours, rivers and creeks. These photographs ferry the viewer to the far reaches of the outer boroughs: Brooklyn, the Bronx, Queens and Staten Island. There, time moves according to season, ceaselessly circling back upon itself, eschewing the forward march of the grid. Daylight lengthens, the water warms and resounds with voices and motors. Daylight shortens, the waters cool into icy silence. Shoreline remnants tangle into fictive histories. Bridges arc from shore to shore, steel longings drawn between boroughs, eternally crossing the tides below.

It avails not, time nor place—distance avails not,
I am with you, you men and women of a generation, or ever so
many generations hence,
Just as you feel when you look on the river and sky, so I felt…

– Walt Whitman, Crossing Brooklyn Ferry

ACKNOWLEDGEMENTS

I am indebted to the New Yorkers who allowed me to witness their moments on the water, as well as to the following organisations and individuals who facilitated voyages on the waterways of New York City: NYCEDC Ferry Service, the North Brooklyn Boat Club, Rocking the Boat, NYC Parks, Rondi Davies and the 8 Bridges Hudson River Swim, Captain Greg Porteus, and Marie Lorenz and the Tide and Current Taxi.

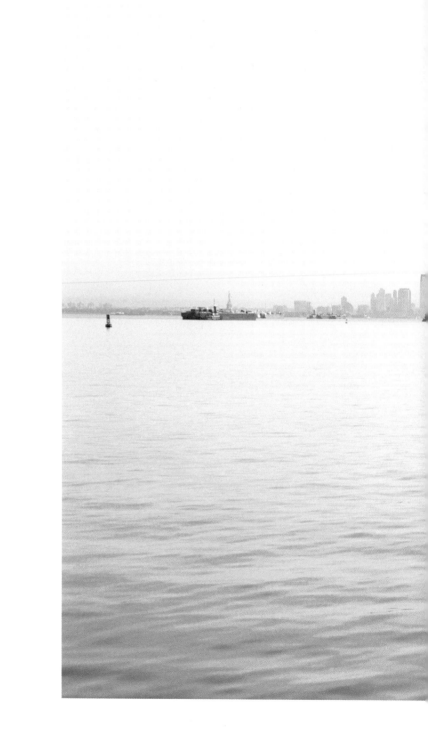

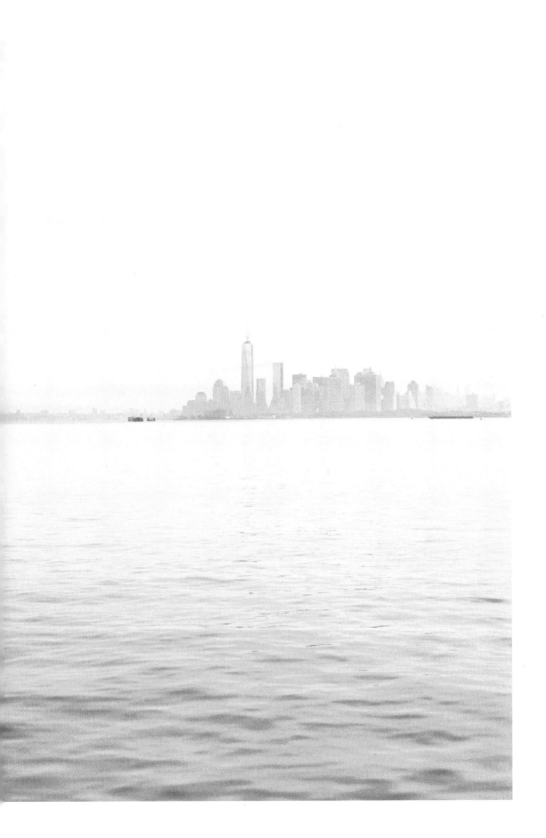

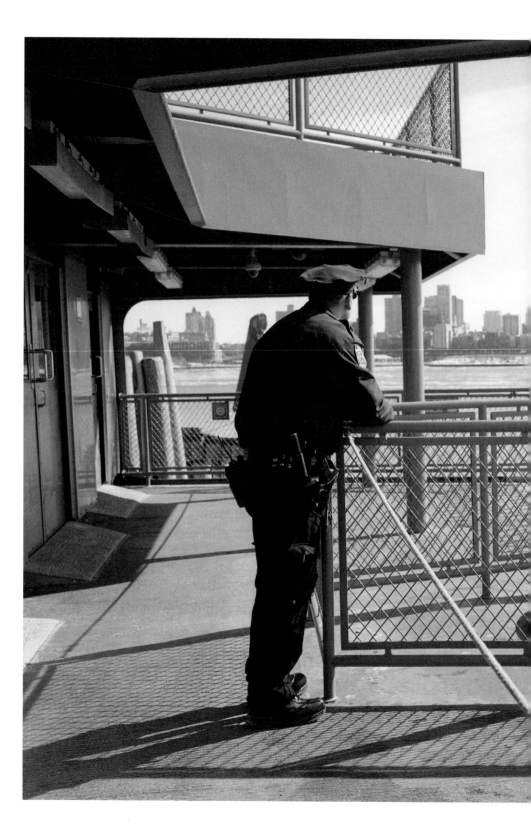

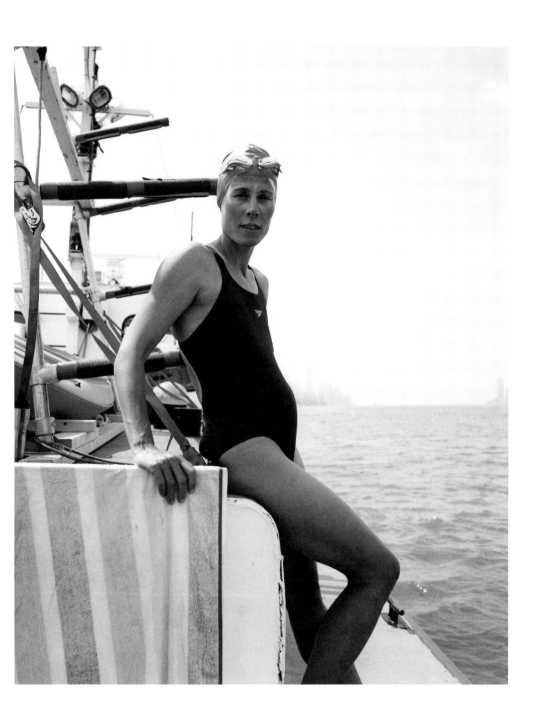

Rondi, 8 Bridges Swim Organiser, the Hudson River

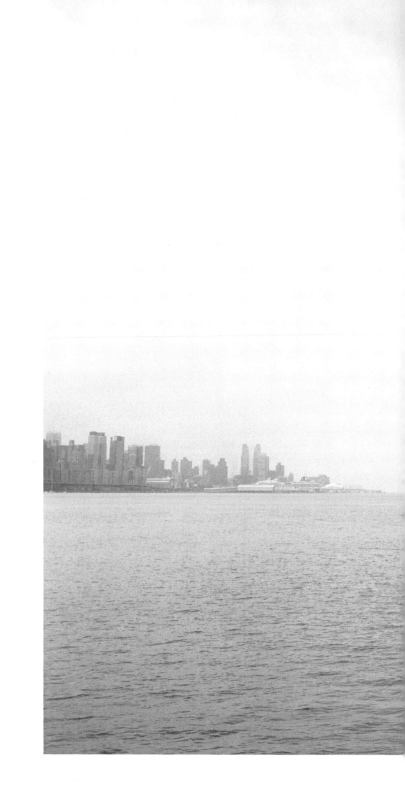

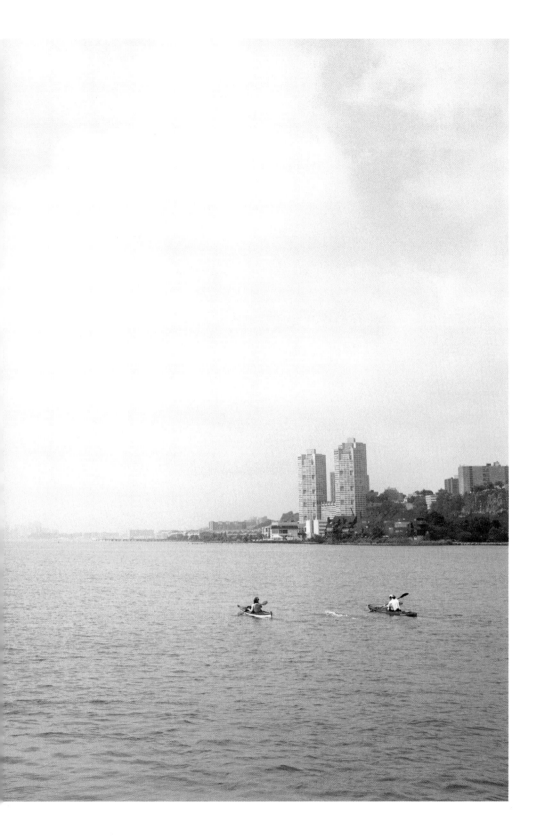

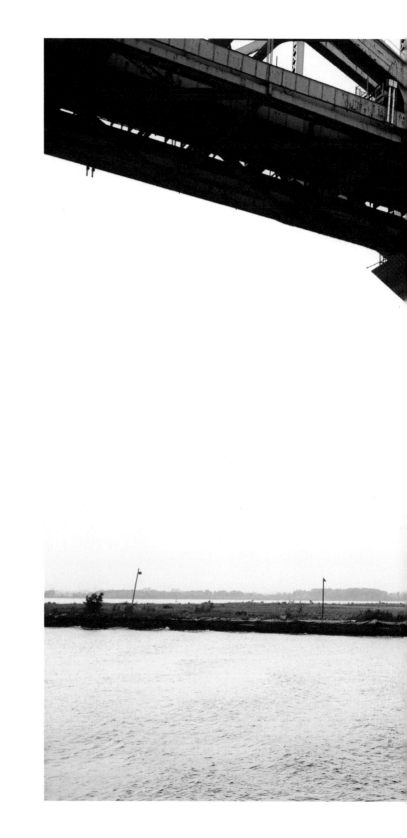

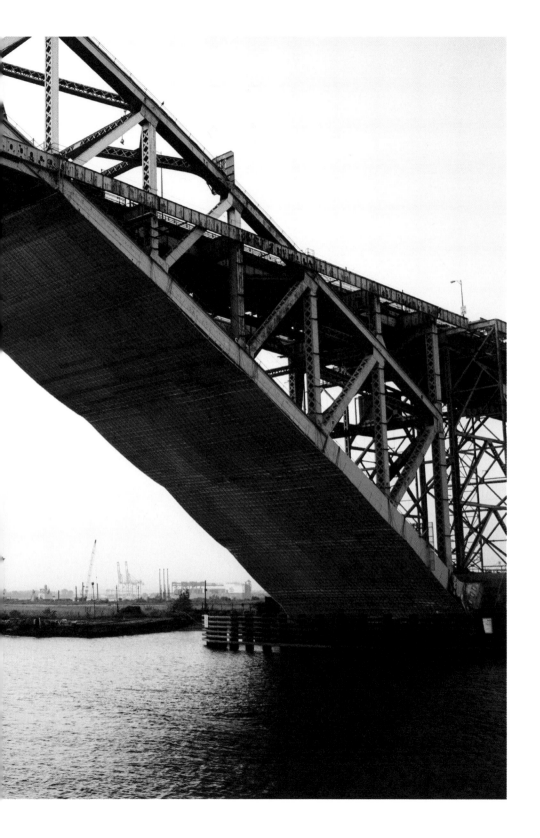

previous pages
Two Kayakers and a Swimmer, the Hudson River
Bayonne Bridge, the Kill Van Kull

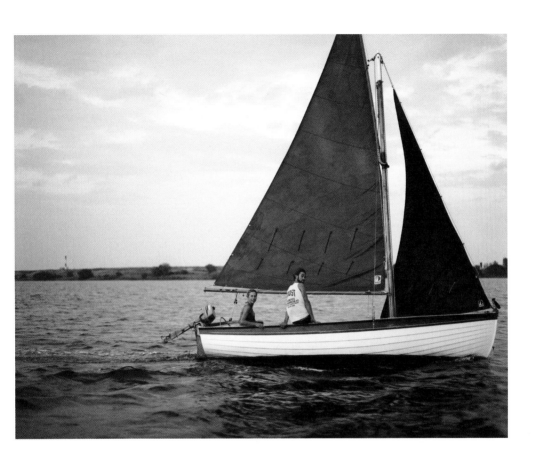

Red Sailboat, Jamaica Bay, Queens

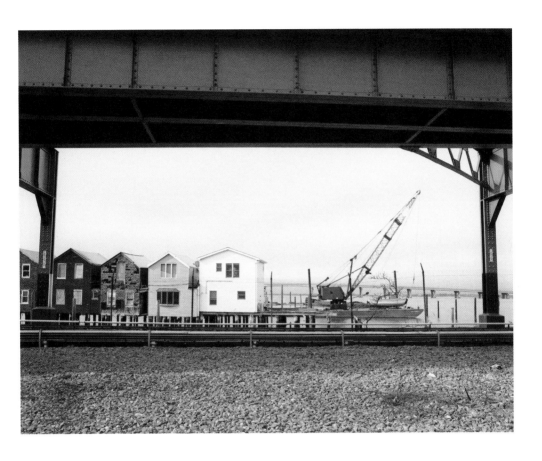

Stilt Houses, Jamaica Bay, Queens

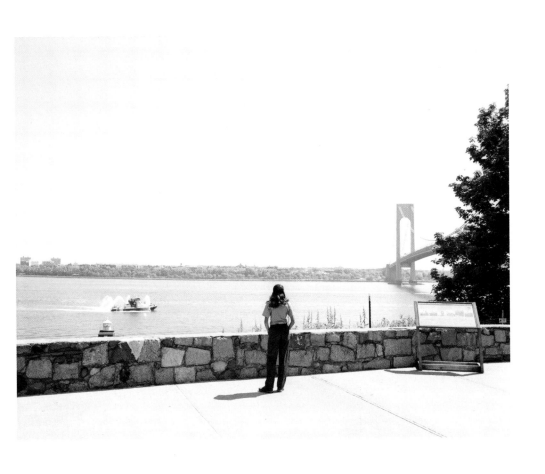

Fleet Week Departs, The Narrows, Staten Island

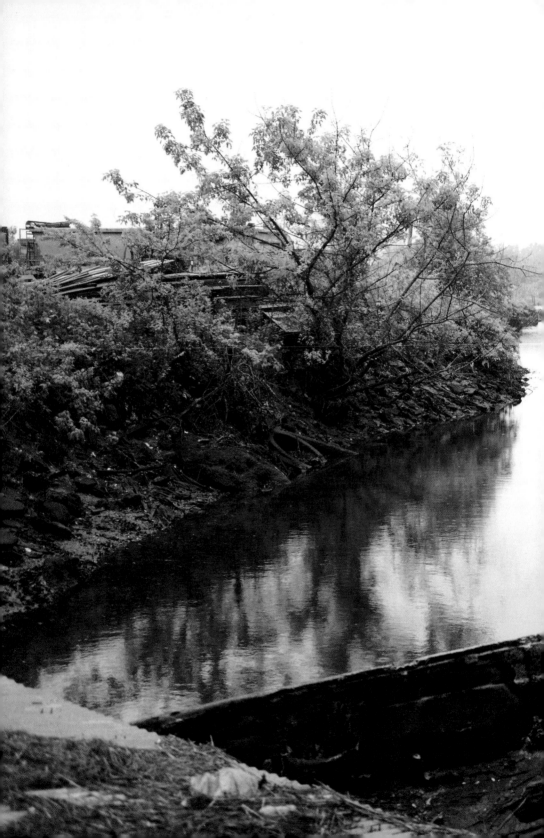

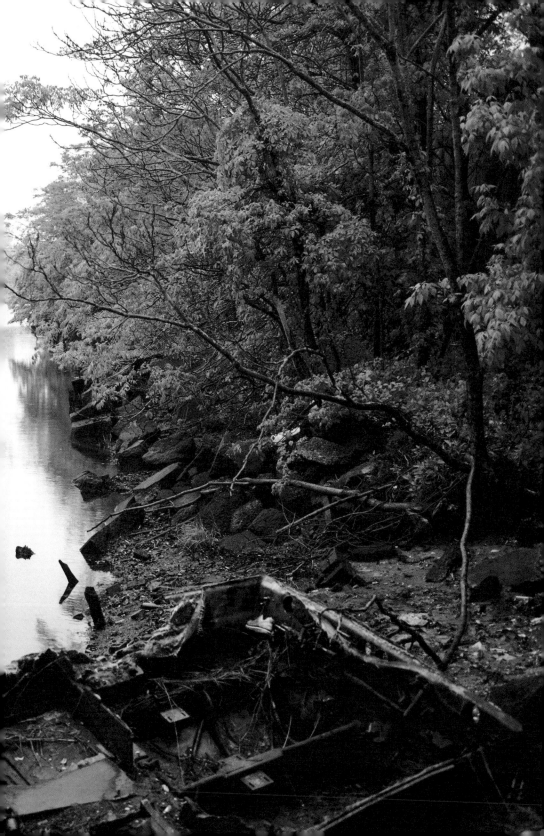

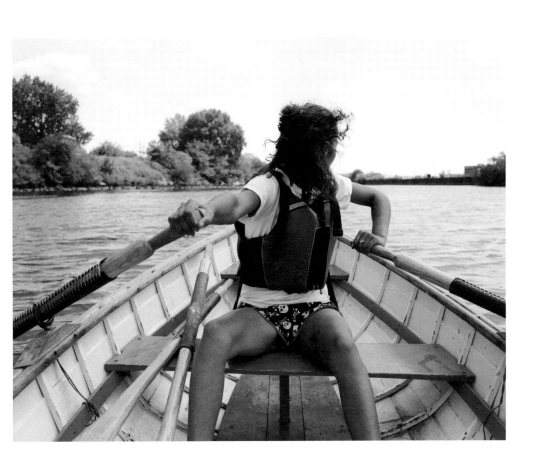

Torey Rowing the Bronx River

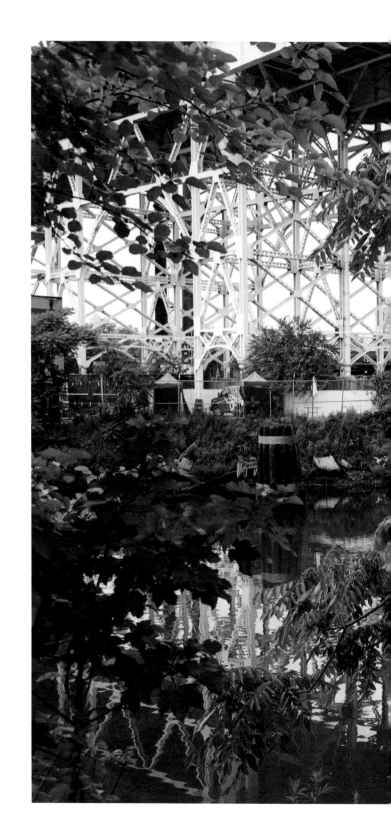

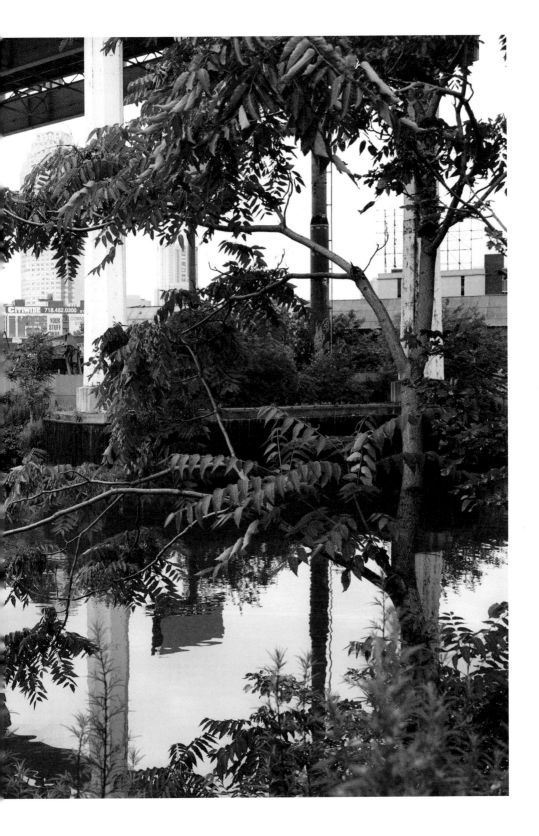

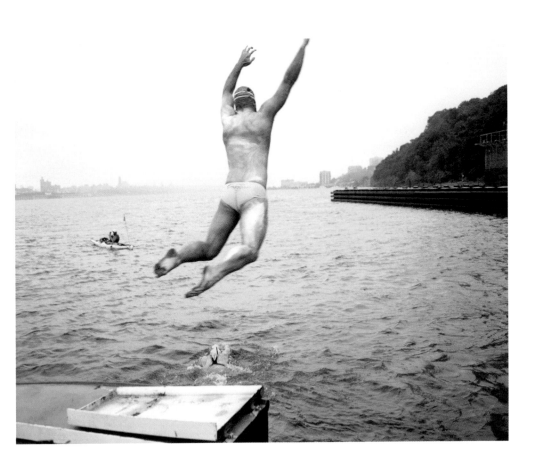

Final Stage, 8 Bridges Swim, the Hudson River

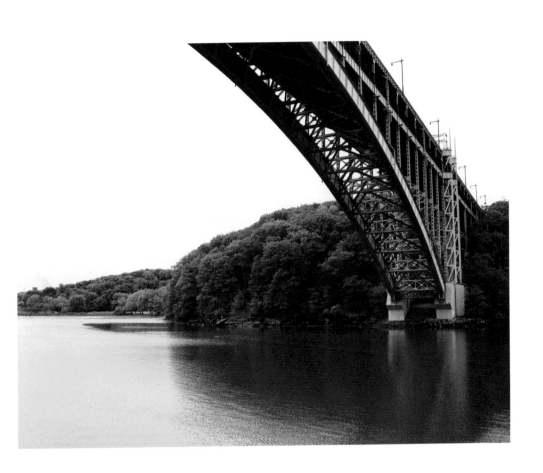

The Henry Hudson Bridge

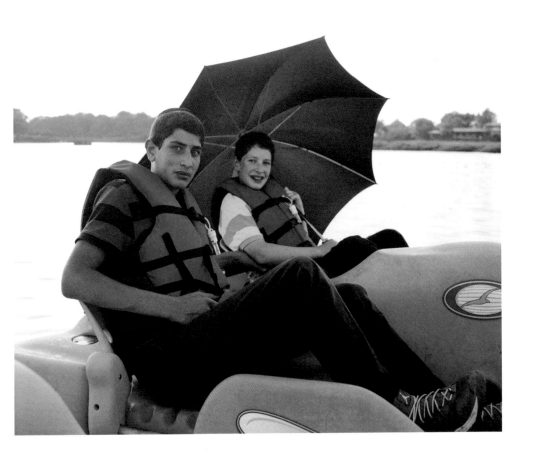

Two Boys in a Pedal Boat, Marine Park, Brooklyn

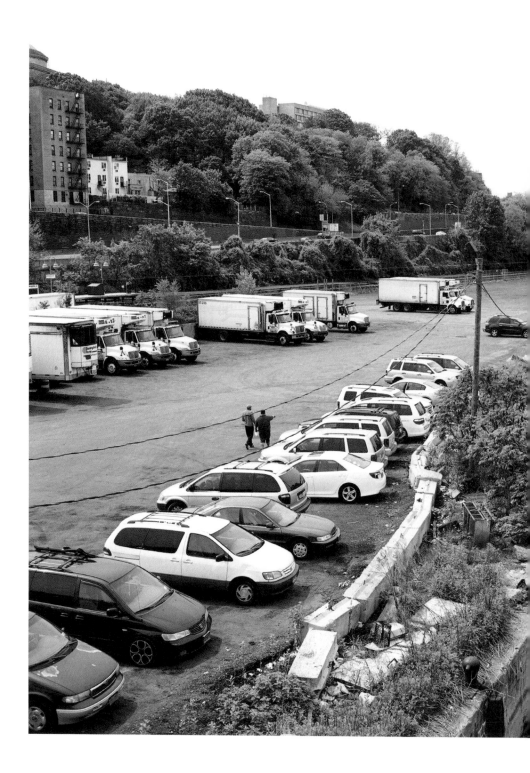

CROSSING BROOKLYN FERRY

by Walt Whitman

1

Flood-tide below me! I see you face to face!
Clouds of the west—sun there half an hour high—I see you also face
 to face.

Crowds of men and women attired in the usual costumes, how curious
 you are to me!
On the ferry-boats the hundreds and hundreds that cross, returning
 home, are more curious to me than you suppose,
And you that shall cross from shore to shore years hence are more to me,
 and more in my meditations, than you might suppose.

2

The impalpable sustenance of me from all things at all hours of the day,
The simple, compact, well-join'd scheme, myself disintegrated, every one
 disintegrated yet part of the scheme,
The similitudes of the past and those of the future,
The glories strung like beads on my smallest sights and hearings, on the
 walk in the street and the passage over the river,
The current rushing so swiftly and swimming with me far away,
The others that are to follow me, the ties between me and them,
The certainty of others, the life, love, sight, hearing of others.

Others will enter the gates of the ferry and cross from shore to shore,
Others will watch the run of the flood-tide,
Others will see the shipping of Manhattan north and west, and the
heights of Brooklyn to the south and east,
Others will see the islands large and small;
Fifty years hence, others will see them as they cross, the sun half an
hour high,
A hundred years hence, or ever so many hundred years hence, others
will see them,
Will enjoy the sunset, the pouring-in of the flood-tide, the falling-back
to the sea of the ebb-tide.

3

It avails not, time nor place—distance avails not,
I am with you, you men and women of a generation, or ever so many
generations hence,
Just as you feel when you look on the river and sky, so I felt,
Just as any of you is one of a living crowd, I was one of a crowd,
Just as you are refresh'd by the gladness of the river and the bright flow,
I was refresh'd,
Just as you stand and lean on the rail, yet hurry with the swift current,
I stood yet was hurried,
Just as you look on the numberless masts of ships and the thick-stemm'd
pipes of steamboats, I look'd.

I too many and many a time cross'd the river of old,
Watched the Twelfth-month sea-gulls, saw them high in the air floating
with motionless wings, oscillating their bodies,
Saw how the glistening yellow lit up parts of their bodies and left the rest
in strong shadow,
Saw the slow-wheeling circles and the gradual edging toward the south,
Saw the reflection of the summer sky in the water,
Had my eyes dazzled by the shimmering track of beams,

Look'd at the fine centrifugal spokes of light round the shape of my head
 in the sunlit water,
Look'd on the haze on the hills southward and south-westward,
Look'd on the vapor as it flew in fleeces tinged with violet,
Look'd toward the lower bay to notice the vessels arriving,
Saw their approach, saw aboard those that were near me,
Saw the white sails of schooners and sloops, saw the ships at anchor,
The sailors at work in the rigging or out astride the spars,
The round masts, the swinging motion of the hulls, the slender
 serpentine pennants,
The large and small steamers in motion, the pilots in their pilot-houses,
The white wake left by the passage, the quick tremulous whirl of the
 wheels,
The flags of all nations, the falling of them at sunset,
The scallop-edged waves in the twilight, the ladled cups, the frolicsome
 crests and glistening,
The stretch afar growing dimmer and dimmer, the gray walls of the
 granite storehouses by the docks,
On the river the shadowy group, the big steam-tug closely flank'd on each
 side by the barges, the hay-boat, the belated lighter,
On the neighboring shore the fires from the foundry chimneys burning
 high and glaringly into the night,
Casting their flicker of black contrasted with wild red and yellow light
 over the tops of houses, and down into the clefts of streets.

4
These and all else were to me the same as they are to you,
I loved well those cities, loved well the stately and rapid river,
The men and women I saw were all near to me,
Others the same—others who look back on me because I look'd forward
 to them,
(The time will come, though I stop here to-day and to-night.)

5

What is it then between us?
What is the count of the scores or hundreds of years between us?

Whatever it is, it avails not—distance avails not, and place avails not,
I too lived, Brooklyn of ample hills was mine,
I too walk'd the streets of Manhattan island, and bathed in the waters
 around it,
I too felt the curious abrupt questionings stir within me,
In the day among crowds of people sometimes they came upon me,
In my walks home late at night or as I lay in my bed they came upon
 me,
I too had been struck from the float forever held in solution,
I too had receiv'd identity by my body,
That I was I knew was of my body, and what I should be I knew I
 should be of my body.

6

It is not upon you alone the dark patches fall,
The dark threw its patches down upon me also,
The best I had done seem'd to me blank and suspicious,
My great thoughts as I supposed them, were they not in reality meagre?
Nor is it you alone who know what it is to be evil,
I am he who knew what it was to be evil,
I too knitted the old knot of contrariety,
Blabb'd, blush'd, resented, lied, stole, grudg'd,
Had guile, anger, lust, hot wishes I dared not speak,
Was wayward, vain, greedy, shallow, sly, cowardly, malignant,
The wolf, the snake, the hog, not wanting in me,
The cheating look, the frivolous word, the adulterous wish, not wanting,
Refusals, hates, postponements, meanness, laziness, none of these
 wanting,
Was one with the rest, the days and haps of the rest,

Was call'd by my nighest name by clear loud voices of young men as they
 saw me approaching or passing,
Felt their arms on my neck as I stood, or the negligent leaning of their
 flesh against me as I sat,
Saw many I loved in the street or ferry-boat or public assembly, yet never
 told them a word,
Lived the same life with the rest, the same old laughing, gnawing,
 sleeping,

Play'd the part that still looks back on the actor or actress,
The same old role, the role that is what we make it, as great as we like,
Or as small as we like, or both great and small.

7

Closer yet I approach you,
What thought you have of me now, I had as much of you—I laid in my
 stores in advance,
I consider'd long and seriously of you before you were born.

Who was to know what should come home to me?
Who knows but I am enjoying this?
Who knows, for all the distance, but I am as good as looking at you now,
 for all you cannot see me?

8

Ah, what can ever be more stately and admirable to me than mast-
 hemm'd Manhattan?
River and sunset and scallop-edg'd waves of flood-tide?
The sea-gulls oscillating their bodies, the hay-boat in the twilight, and the
 belated lighter?

What gods can exceed these that clasp me by the hand, and with voices I
 love call me promptly and loudly by my nighest name as I approach?

What is more subtle than this which ties me to the woman or man that
 looks in my face?
Which fuses me into you now, and pours my meaning into you?

We understand then do we not?
What I promis'd without mentioning it, have you not accepted?
What the study could not teach—what the preaching could not
 accomplish is accomplish'd, is it not?

9

Flow on, river! flow with the flood-tide, and ebb with the ebb-tide!
Frolic on, crested and scallop-edg'd waves!
Gorgeous clouds of the sunset! drench with your splendor me, or the
 men and women generations after me!
Cross from shore to shore, countless crowds of passengers!
Stand up, tall masts of Mannahatta! stand up, beautiful hills of Brooklyn!
Throb, baffled and curious brain! throw out questions and answers!
Suspend here and everywhere, eternal float of solution!
Gaze, loving and thirsting eyes, in the house or street or public assembly!

Sound out, voices of young men! loudly and musically call me by my
 nighest name!
Live, old life! play the part that looks back on the actor or actress!
Play the old role, the role that is great or small according as one makes it!
Consider, you who peruse me, whether I may not in unknown ways be
 looking upon you;
Be firm, rail over the river, to support those who lean idly, yet haste with
 the hasting current;
Fly on, sea-birds! fly sideways, or wheel in large circles high in the air;
Receive the summer sky, you water, and faithfully hold it till all downcast
 eyes have time to take it from you!
Diverge, fine spokes of light, from the shape of my head, or any one's
 head, in the sunlit water!

Come on, ships from the lower bay! pass up or down, white-sail'd
 schooners, sloops, lighters!
Flaunt away, flags of all nations! be duly lower'd at sunset!
Burn high your fires, foundry chimneys! cast black shadows at nightfall!
 cast red and yellow light over the tops of the houses!

Appearances, now or henceforth, indicate what you are,
You necessary film, continue to envelop the soul,
About my body for me, and your body for you, be hung out divinest
 aromas,
Thrive, cities—bring your freight, bring your shows, ample and sufficient
 rivers,
Expand, being than which none else is perhaps more spiritual,
Keep your places, objects than which none else is more lasting.

You have waited, you always wait, you dumb, beautiful ministers,
We receive you with free sense at last, and are insatiate henceforward,
Not you any more shall be able to foil us, or withhold yourselves from us,
We use you, and do not cast you aside—we plant you permanently
 within us,
We fathom you not—we love you—there is perfection in you also,
You furnish your parts toward eternity,
Great or small, you furnish your parts toward the soul.

SUSANNAH RAY

Susannah Ray lives in the Rockaways, a small peninsula on the edge of New York City bordered by the Atlantic Ocean, Jamaica Bay and JFK International Airport. This intersection of city and water is at the heart of her photography and extends her early interest in landscape photography, which she uses as a form of visual geography, rendering the complex interrelationships of place, history, and ideology.

Born in 1972 in Washington, D.C, Susannah Ray studied photography at Princeton University and the School of Visual Arts MFA Program in Photography and Related Media. Susannah Ray is an Associate Professor of Photography at Hofstra University.

HOXTON MINI PRESS

We make small collectable photobooks. The kind that we would buy for ourselves. This is Book Five from a series called *Tales from the City* that celebrates the best in urban photography from around the world. Our goal is to make photobooks that are beautiful but also accessible. Not aloof. We want both collectors and everyday folk to keep them in neat piles on wooden shelves.

We are Ann and Martin and have two dogs, Moose and Bug, both of whom hate art. We are based in Hackney, East London. It's where we nurture our ideas, walk the dogs and meet people more talented than ourselves. Thank you for supporting us.

www.hoxtonminipress.com

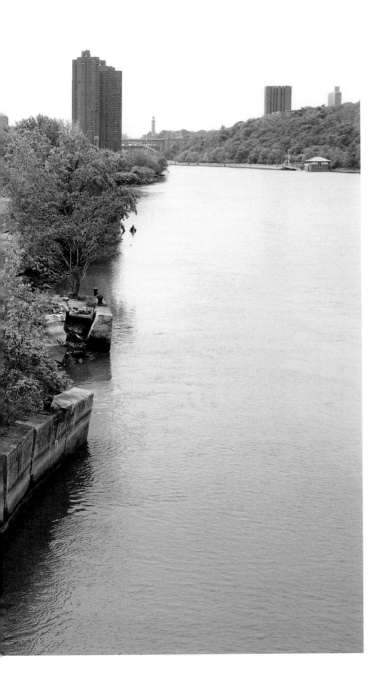

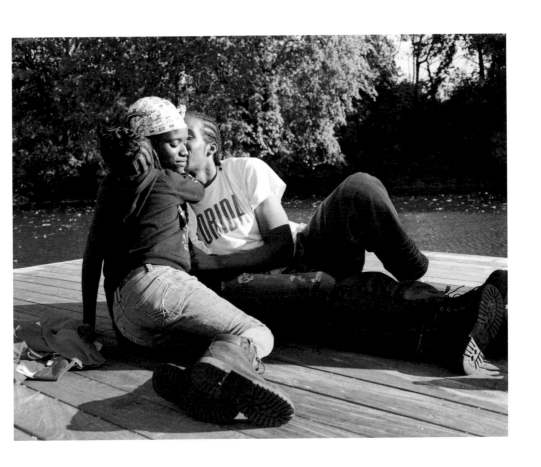

Family, Starlight Park, the Bronx River

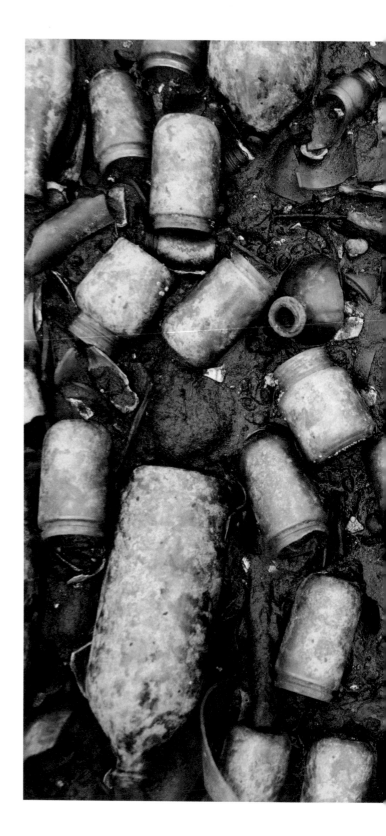

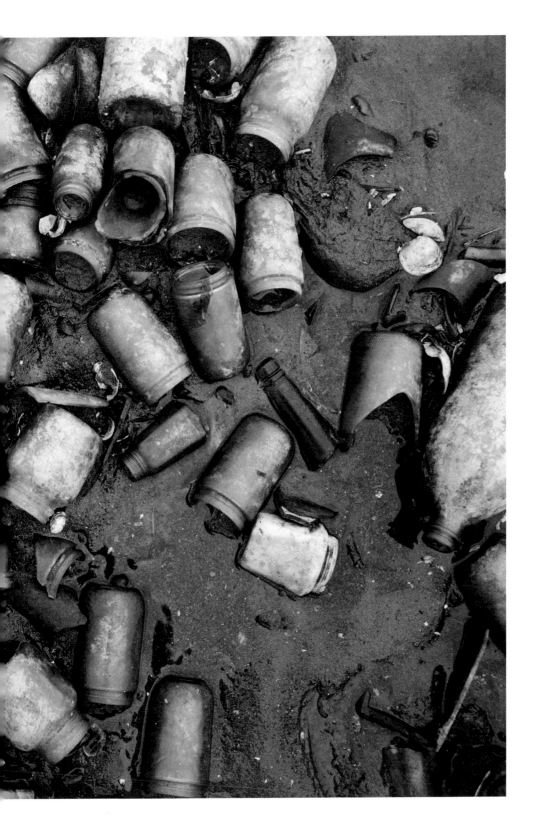

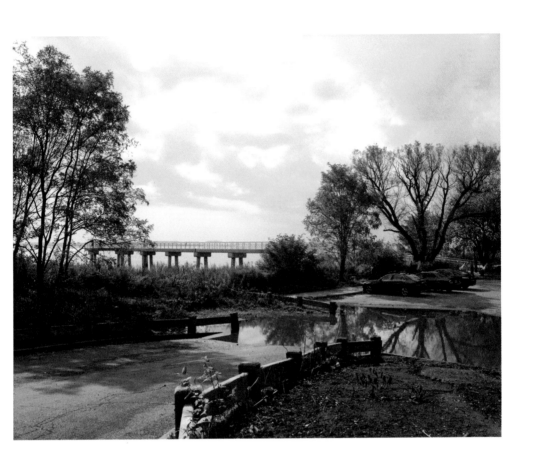

Parking Lot, Prince's Bay, Staten Island

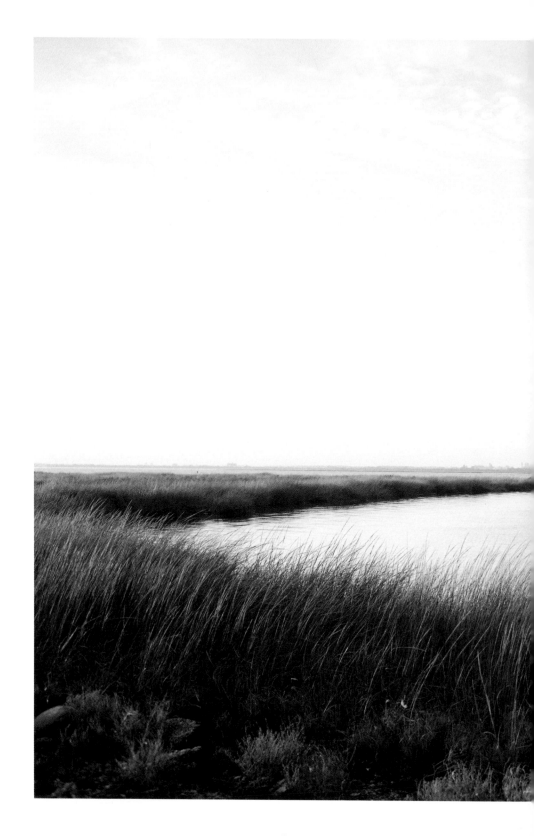

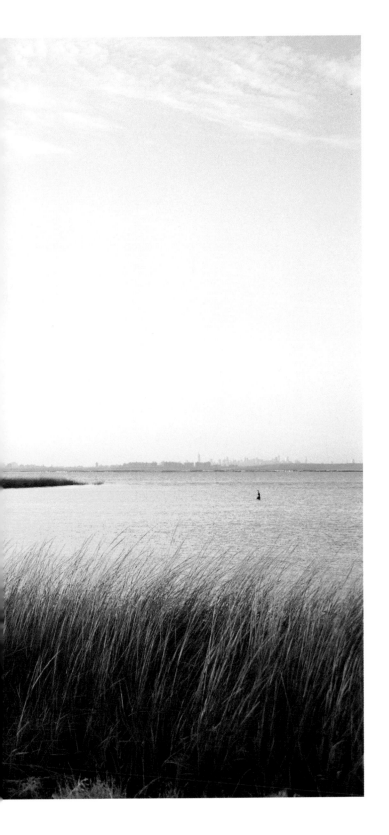

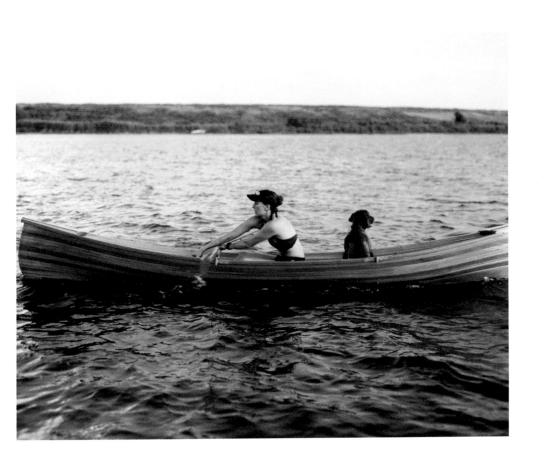

Woman Rowing Dogs, Jamaica Bay, Queens

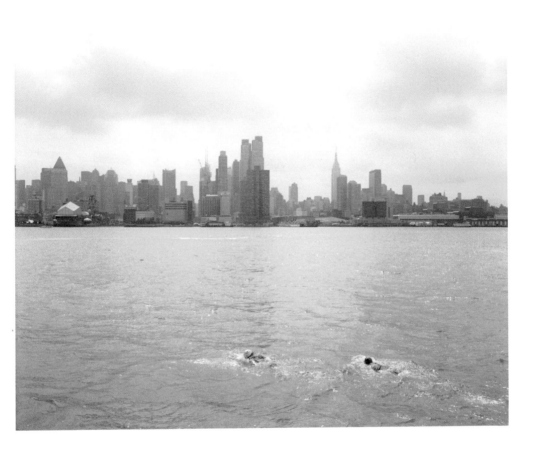

Swimmers, the Hudson River

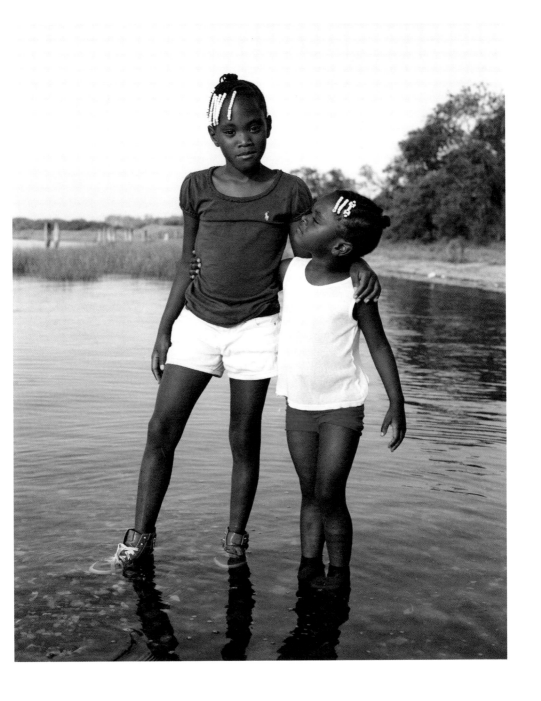

Sisters, Jamaica Bay, Queens

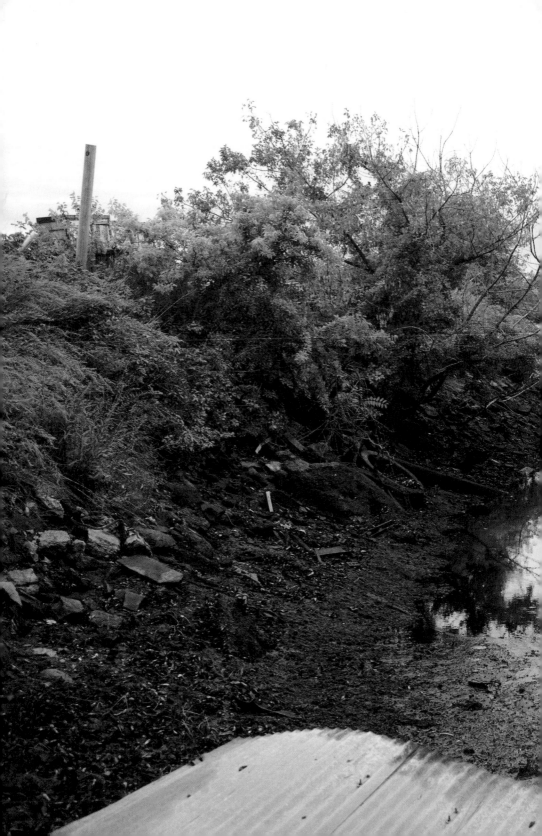

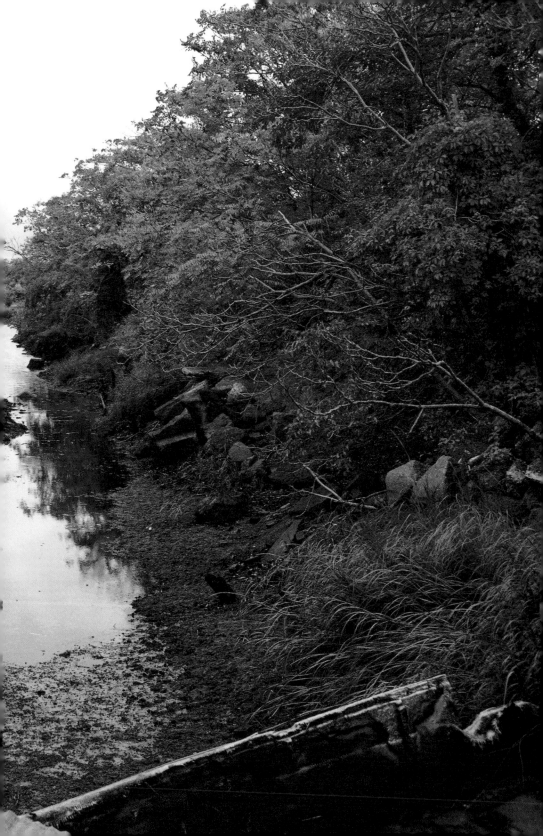

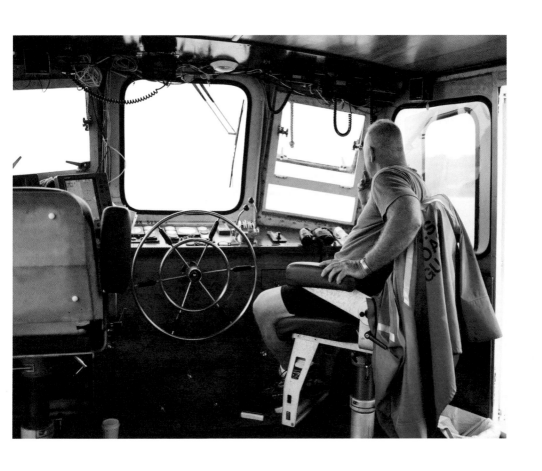

Captain Greg Porteus, Launch 5, the Hudson River

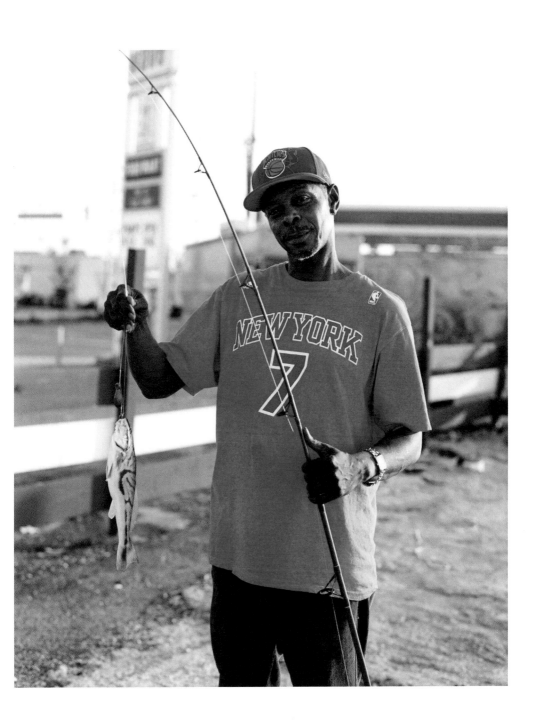

Kenny and His Catch, Jamaica Bay, Queens

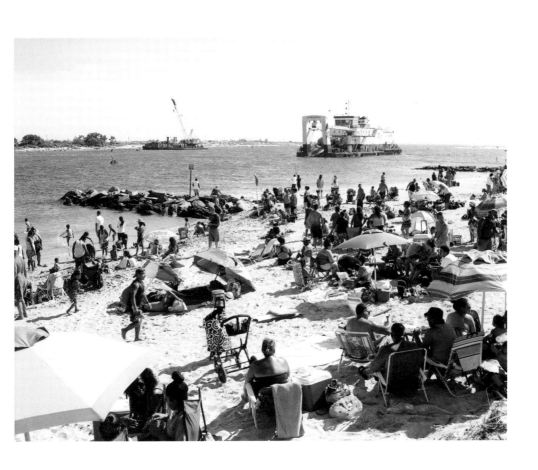

Reynolds Channel, Queens

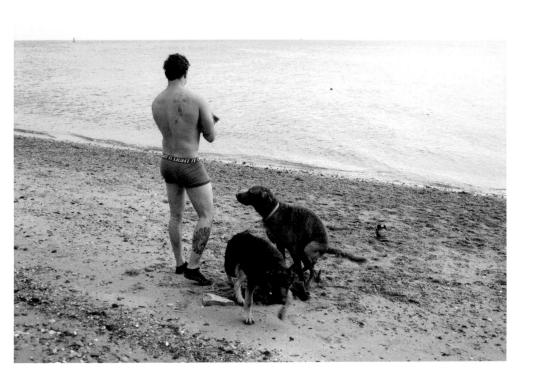

Man and Two Dogs, Prince's Bay, Staten Island

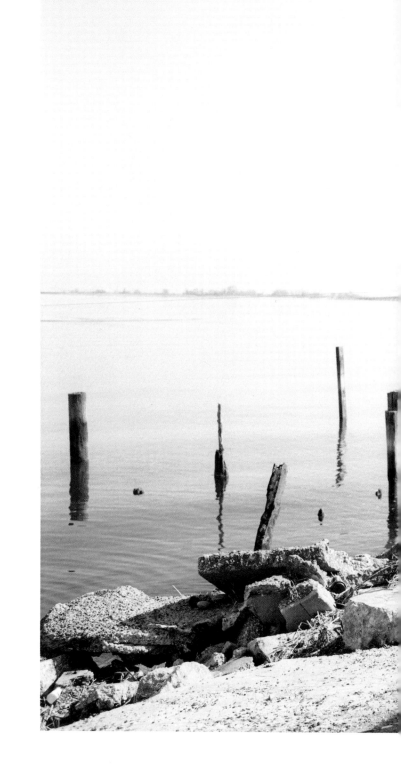

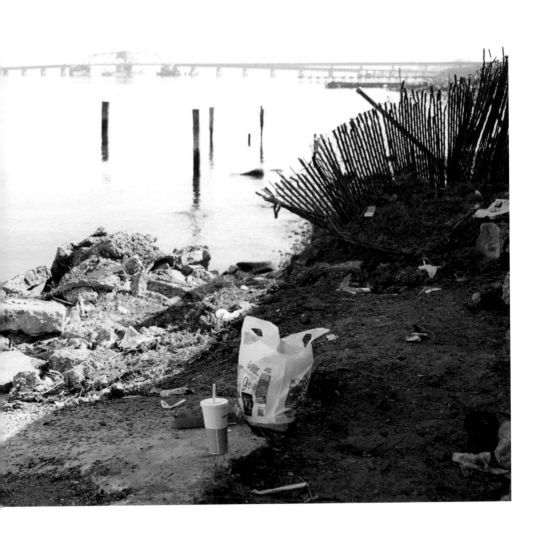

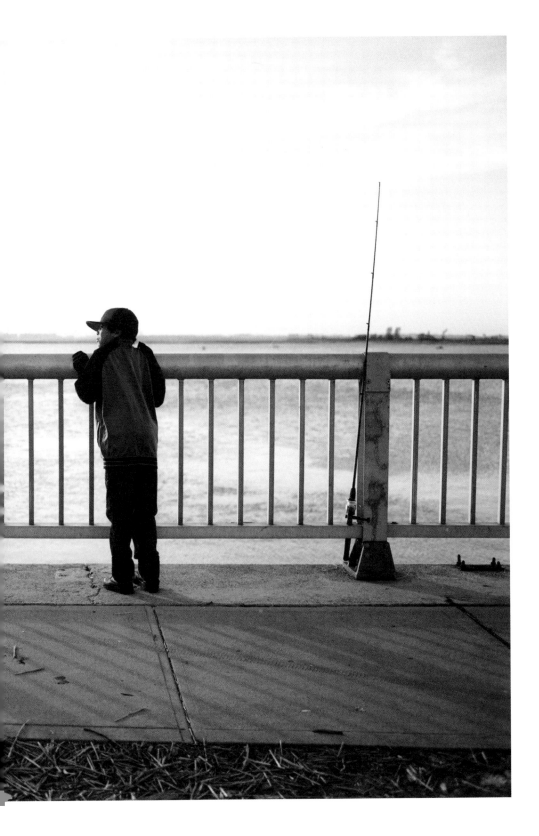

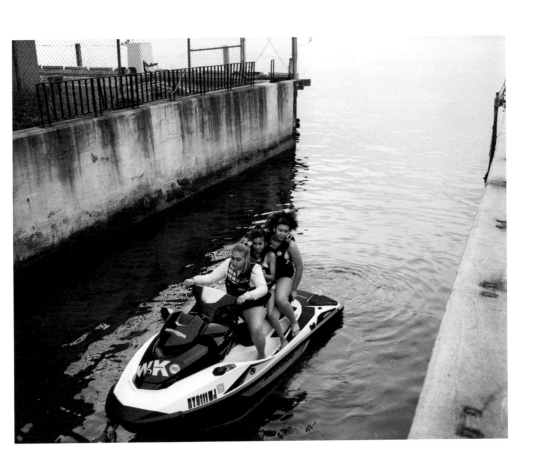

Three Girls on a Jet Ski, Jamaica Bay, Queens

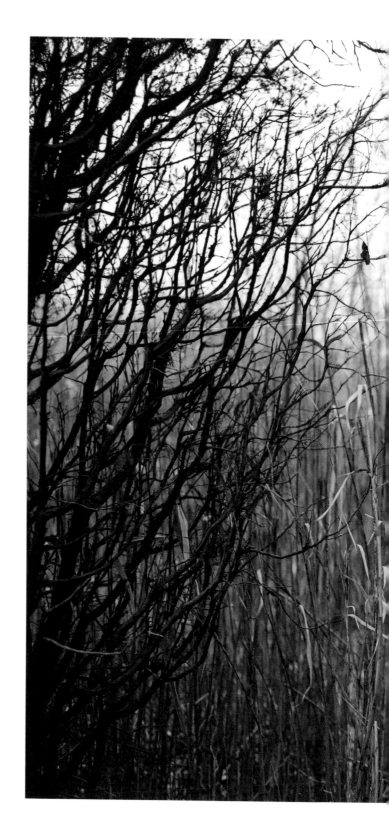

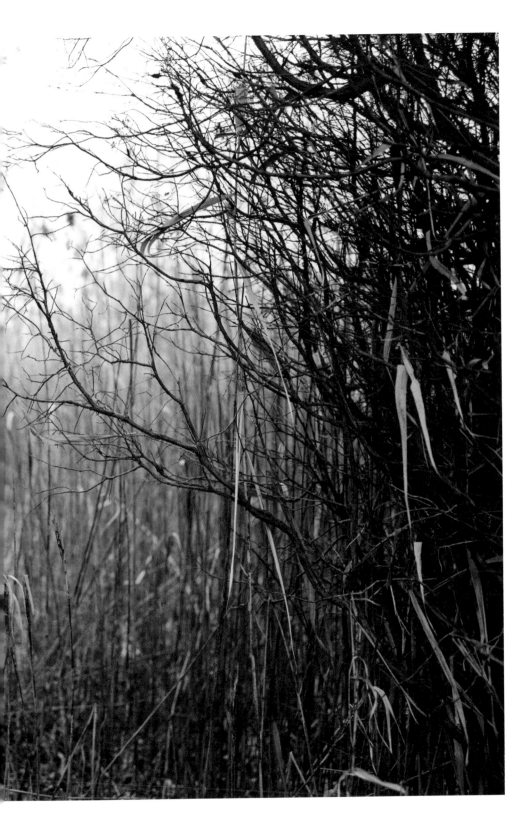

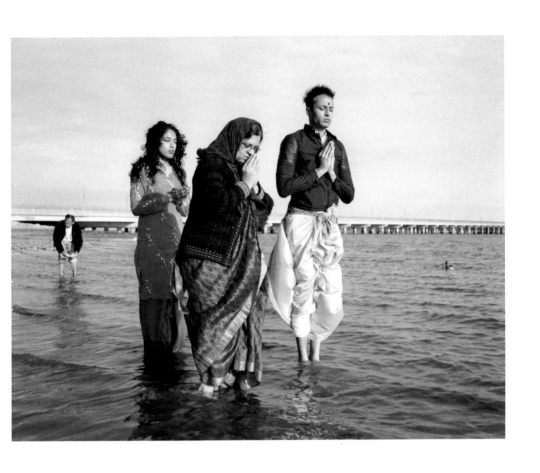

Prayers and Offerings, Jamaica Bay, Queens

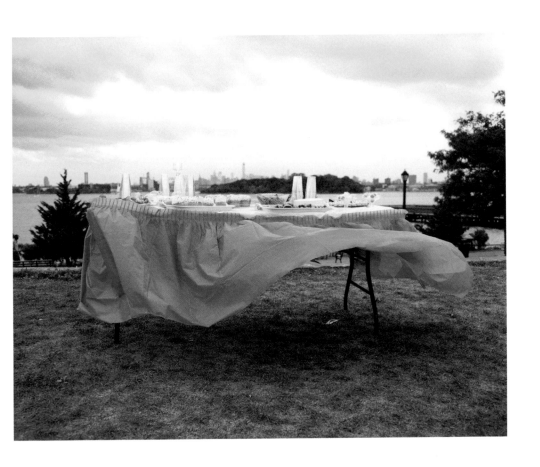

Dessert Table, Barretto Point Park, the Bronx

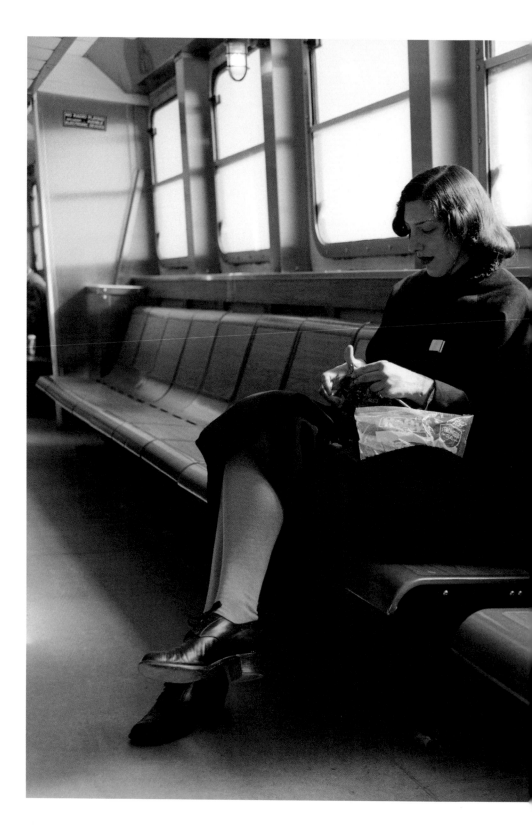

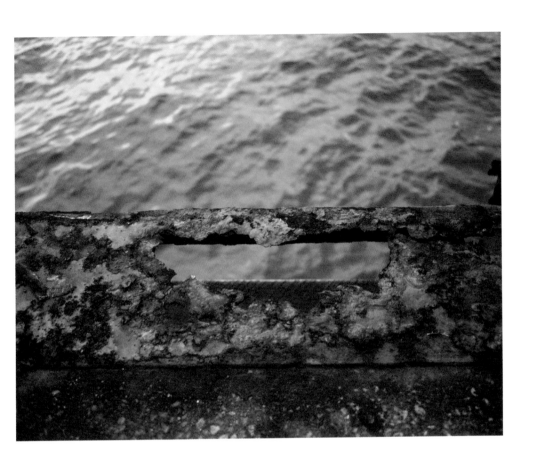

Rust and Water, Jamaica Bay, Queens

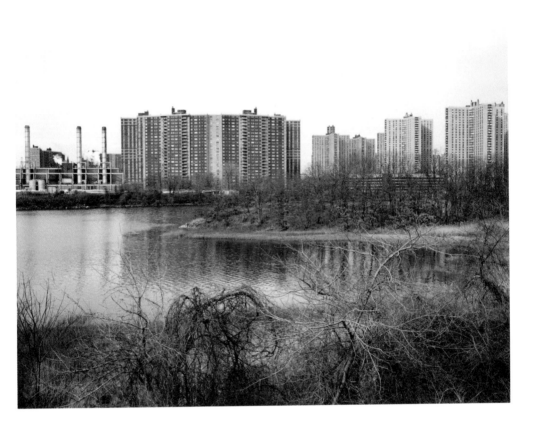

The Hutchinson River and Co-op City, the Bronx

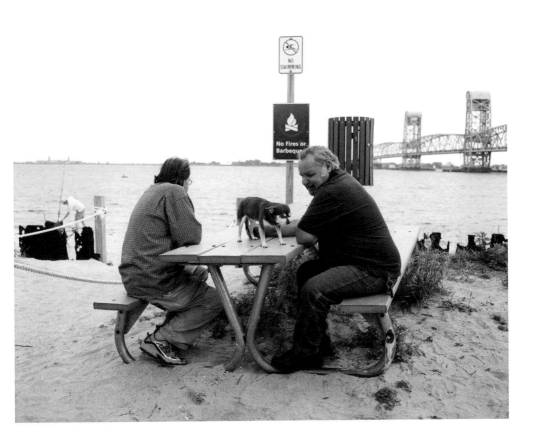

Two Men and a Dog, Rockaway Inlet, Brooklyn

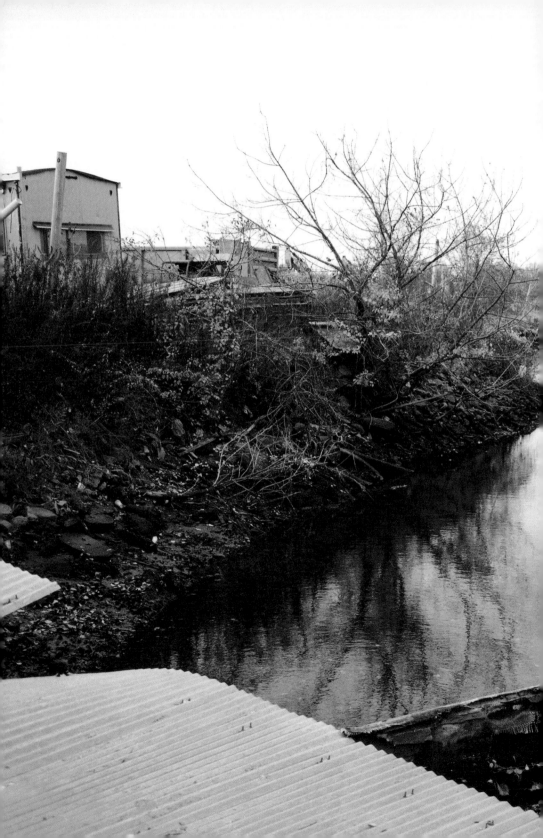

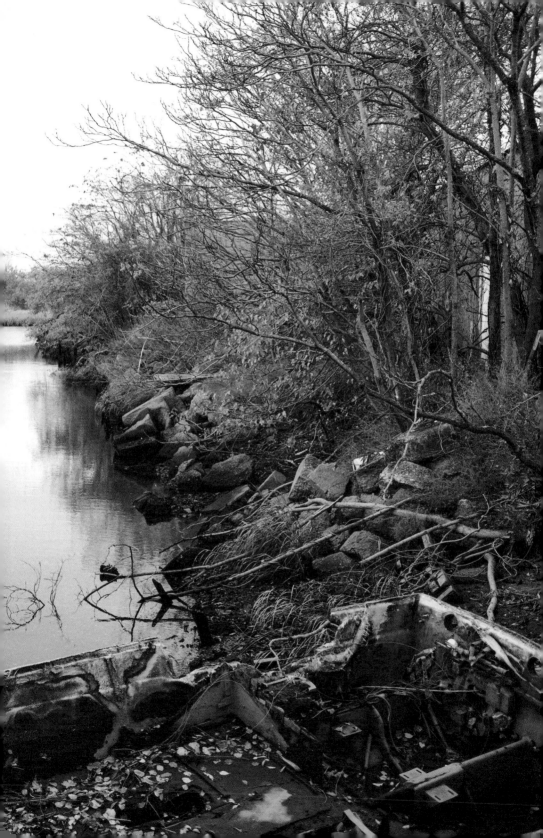

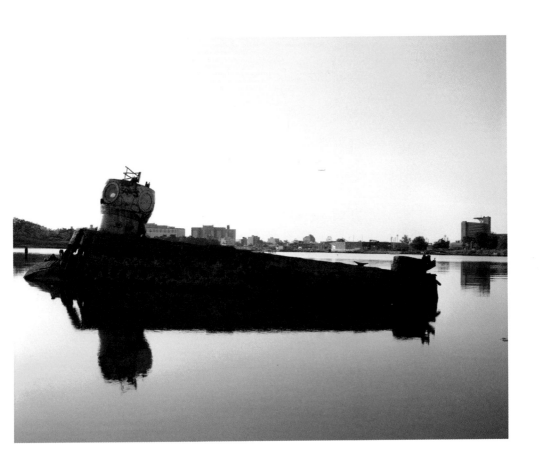

Submarine, Coney Island Creek, Brooklyn

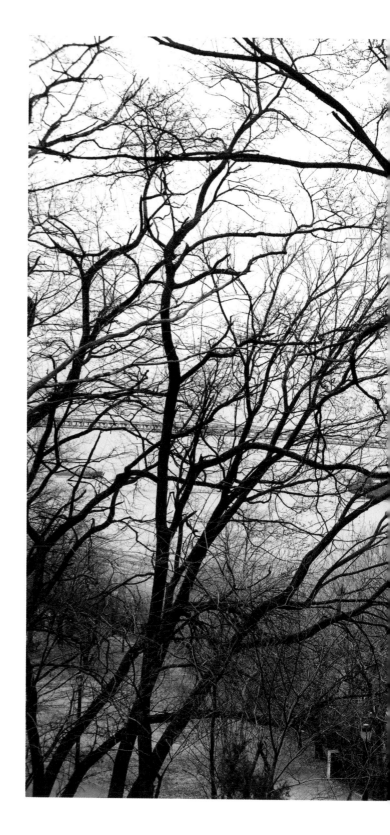

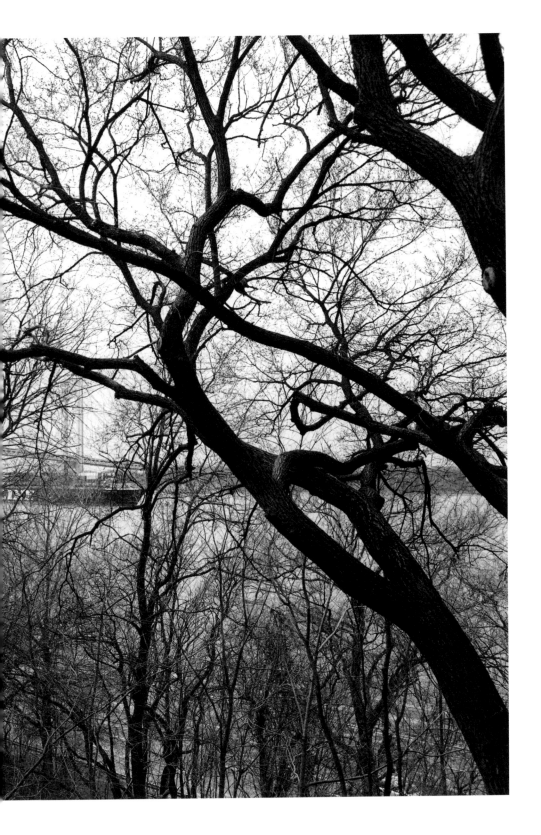

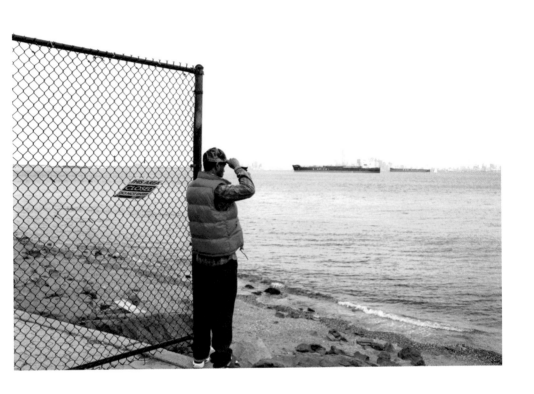

Looking to The Narrows, Staten Island

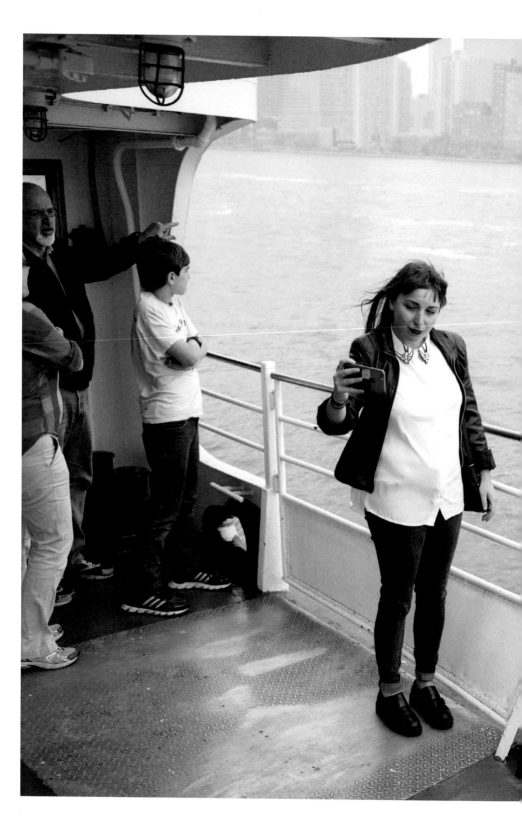

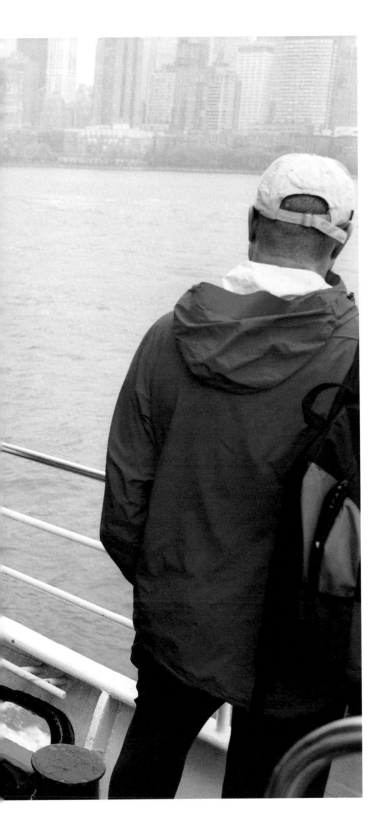

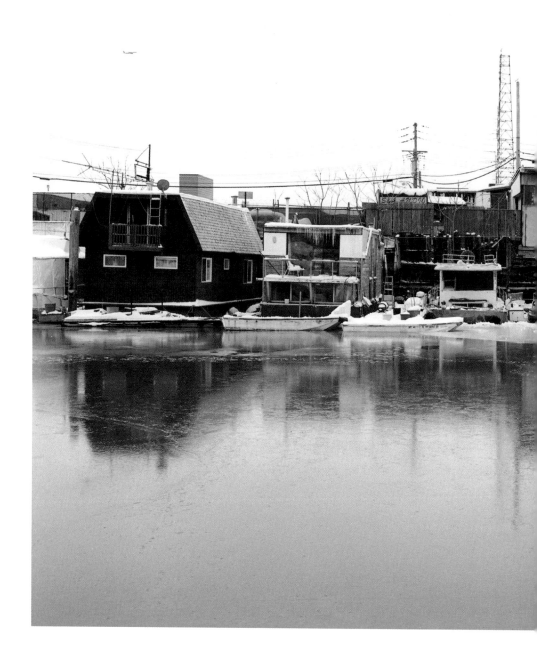

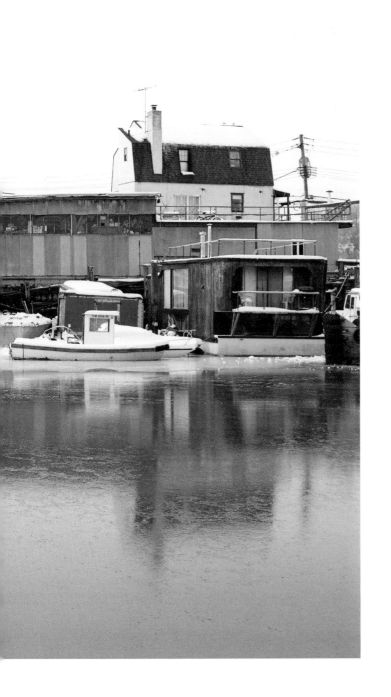

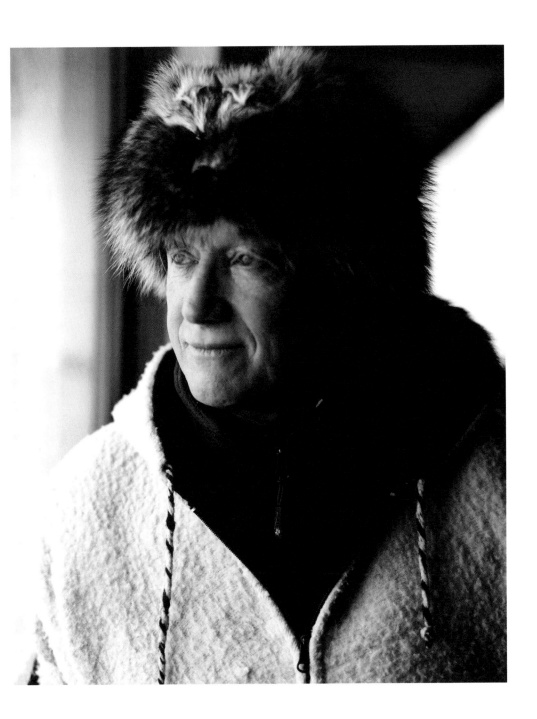

Jacques, East River Ferry

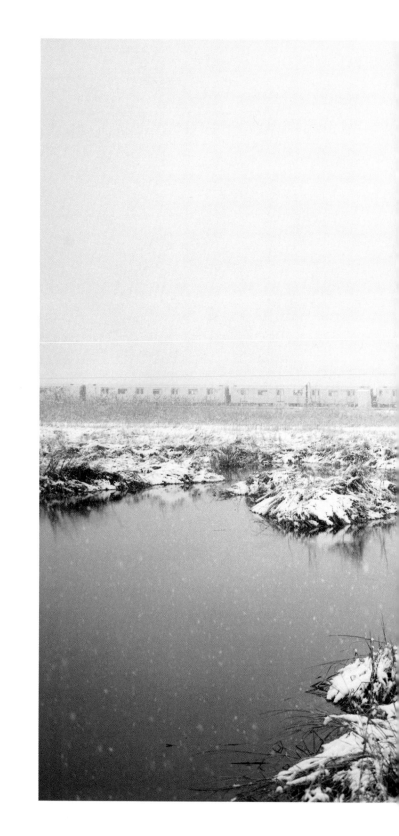

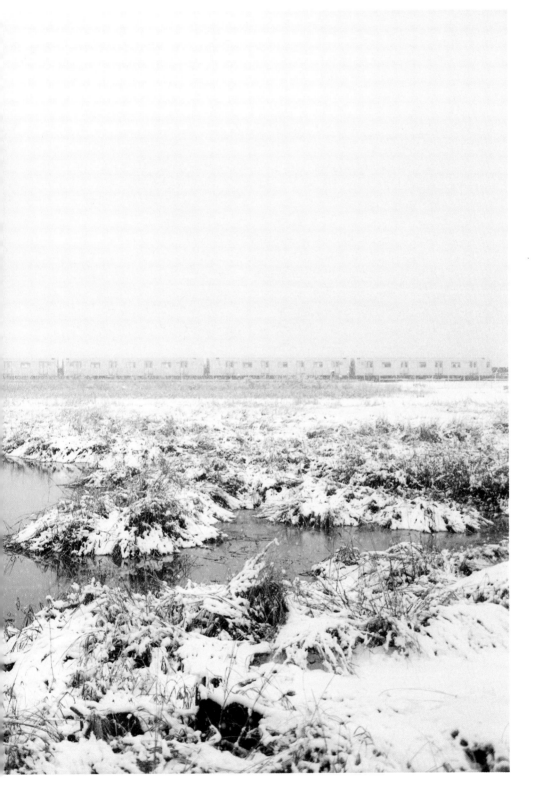

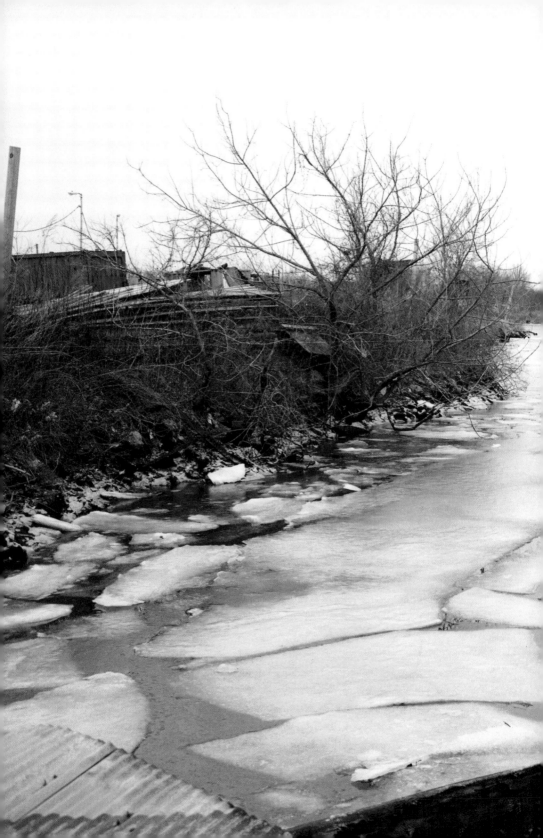

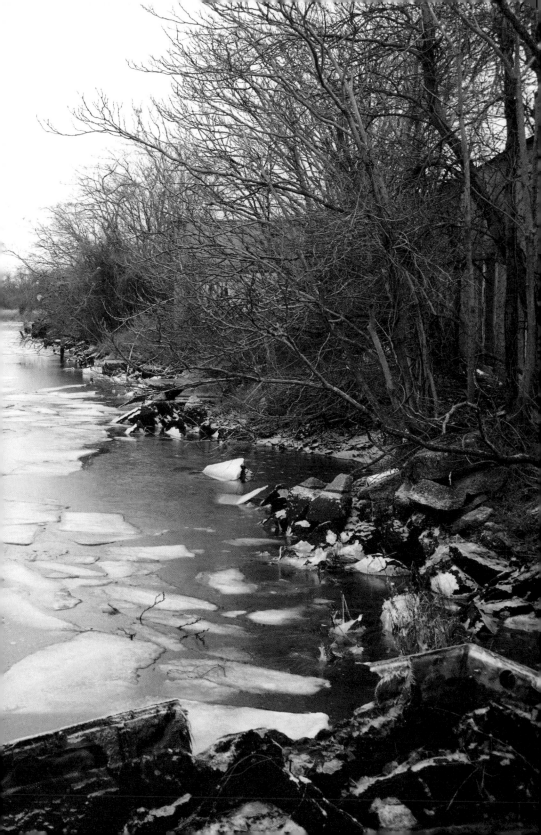

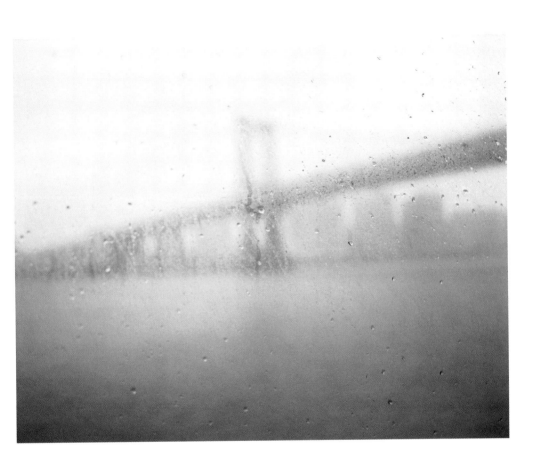

Ferry Window (Williamsburg Bridge)

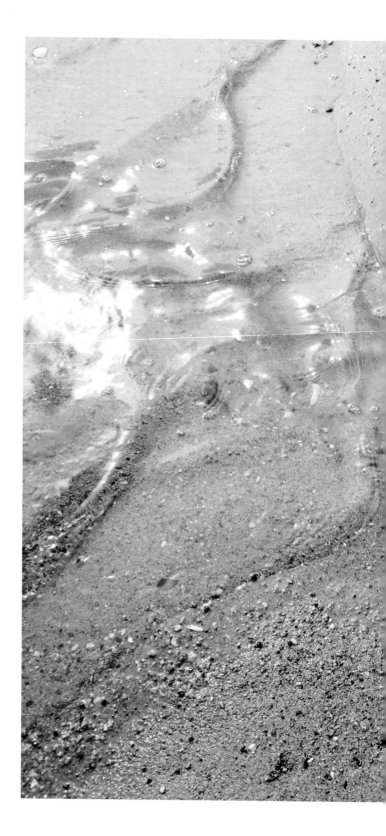

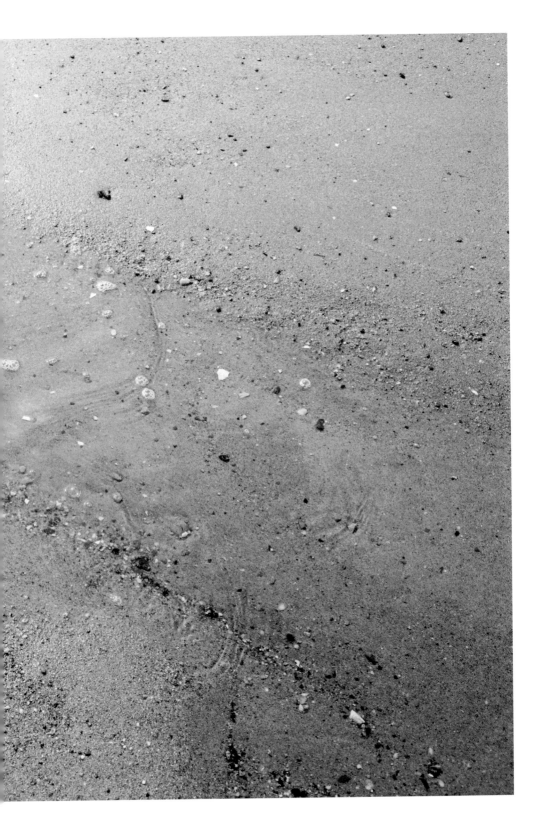

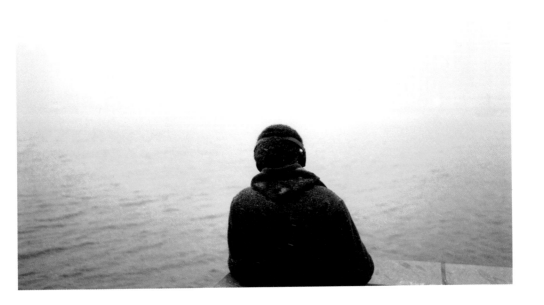

Snowstorm, the East River

New York Waterways

First Edition

Copyright © Hoxton Mini Press 2017. All rights reserved.

All photographs © Susannah Ray

Introduction by Marie Lorenz

'Crossing Brooklyn Ferry' © Walt Whitman,
courtesy of The Walt Whitman Archive

Design and sequence by Friederike Huber, Susannah Ray
and Hoxton Mini Press

A CIP catalogue record for this book is available from the British Library.

ISBN 978-1-910566-27-5

First published in the United Kingdom in 2017 by Hoxton Mini Press
No part of this publication may be reproduced, stored in a retrieval system,
or transmitted in any form or by any means, electronic, mechanical,
photocopying, recording or otherwise, without the prior written
permission of the copyright owner.

Printed and bound by: Livonia Print, Latvia

To order books, collector's editions and signed prints please go to:
www.hoxtonminipress.com

FSC
www.fsc.org

MIX
Paper from
responsible sources
FSC® C002795